Musical Therapy Reconnection

I
Heard My
Child
Singing

**Neurological and Perceptual
Methods for Quickly and Effectively
Extinguishing Traumas in Juveniles**

Created by Earl Steven Lee M.Ed.

A workbook that will help you understand what youth of today are thinking and feeling. This workbook will give you the techniques to effectively deal with juvenile trauma in all settings. Music is the number one mode of communication among youth and it is universal.

authorHOUSE®

ISBN: 978-1-4033-1024-8 (e)
ISBN: 978-1-4033-1025-5 (sc)

This book is printed on acid free paper.

1stBooks - rev. 02/17/03

Music Therapy Reconnection (MTR) is the answer to solving the trauma issues surrounding the tragedy of September 11, 2001. Dr. Anne Blood and her co-author, Robert Zatorre of McGill University in Montreal used position emission tomography, or pet scans, to find areas of the brain that are stimulated by music found so moving by the test subjects that it "sent shivers down the spine."

"People now are using music to help them deal with sadness and fear," said Dr. Anne Blood, a researcher at Massachusetts General Hospital in Charlestown, Massachusetts. "We are showing in our study that music is triggering systems in the brain that make them feel happy." "The researchers found that many of the brain structures activated by the euphoria of food or sex also are turned on by music." A report on the study is in the September 25, 2001 issue of the proceedings of the National Academy of Science.

Dr. Ira Glick, professor of Psychiatry at Stanford University School of Medicine, said music "is one way to cope" in periods of stress and it is known that "behind ever emotion and every piece of behavior there is a change in a molecule. It is exciting to see the biology unfold before our eyes as we explore the human mind," he said.

Music Therapy Reconnection is the best approach that you will find to date to deal with the trauma in people's lives and to extinguish it. Music Therapy Reconnection is fast, effective, and efficient regarding locating and extinguishing trauma. MTR is the only approach that easily crosses the lines of communication from juvenile to adult communication. Ask and answer this question for yourselves. Wouldn't you like to know what that very special person to you is thinking and feeling? If you know a person with an unbearable situation, wouldn't you want to help? MTR can help within minutes and even extinguish the concern in most cases.

As the creator of Music Therapy Reconnection, I knew that it was very special when I tried it on a group of professionals and most rated it's accuracy regarding the locating of their trauma as a 10 on a scale of 1-10, with 10 being the highest rating and the lowest rating being 1. Only one person scored Music Therapy Reconnection as a 9. Music Therapy Reconnection was copyrighted on August 24, 2000 and is also the newest approach regarding dealing with trauma and extinguishing it.

Sincerely yours,

Earl Steven Lee M.Ed.
Author/Creator of Music Therapy Reconnection

<u>Acknowledgments</u>

I would like to extend a heartfelt thank you to all that have either inspired or participated in the culmination of this book. My mother and father, James and Mitzi Lee, who never gave up on even my wildest dreams. My sons Earl, Brandon, and Jared, who even though hardships were commonplace, never lost the faith that one day all things are possible, "If only you believe." Uncle Crockett, every holiday or event, you made all or our hearts sing with your music. to my sister Lana, you truly are the diamond that illuminates the darkest moments of many a dismal time. Jordon, thank you for your smile and unconditional love and never doubting me. Steve, for the many times we sat down with our instruments and communicated. Thanks to my family for making me sing. Mike Lynch and Hugh Spall, thank you for my new beginning. Thank you for all of you that participated in Music Therapy Reconnection. Before a book is able to be read fluently, denoting the ability to speak and make you feel, becoming cognizant of its intent, you need it edited. Thank you, Mrs. Sharon James for your long hours of work and your wonderful smile and big heart. Thank you, Mrs. Lynn Bundy for the years you have agonized doing my typing. Ms. Louise, your strong will, get down to business attitude and love made me realize that talk is cheap, do what you say. Thanks to all. If I have omitted anyone, know that it was not my intent and I apologize.

To all musicians, artists, music teachers, and to the many stars of screen and stage that have given the world a way to feel and heal.

Table of Contents

SECTION 1

Introduction

MTR, What it will do for you

Music Therapy Reconnection is the best approach to date that you will find. Not only does it give you the vital information that you need right now but information that could take you months to retrieve from traditional methods. What t will do for you:

A. Gives you information about the juvenile's early/present activities.

B. Gives you information about the juvenile's family, early childhood and peer group interactions/involvement.

C. Gives you information regarding what will work with the youth.

D. Gives you all this information in less than 10 minutes by using the Lee Technique for narrowing down forms for quick information and form for more exacting information for treatment plan. <u>Specific information about person's interpersonal and social relationships and music (used to help juveniles understand how to deal with problems)</u>. See Forms Section.

E. Gives you more information than the Maysi, DSM IV, Diagnostic Mental Health Screen and many other popular methods used today.

F. The perfect assessment tool regarding predetermining behaviors that could be detrimental to others or themselves.

G. Music is how our youth of today communicate.

<div align="center">

Music Therapy Reconnection
Is
Simply Amazing

</div>

Created by Earl S. Lee, M.ED.

Short Overview of MTR Result

The results of my findings 100 percent agree with my Music Therapy reconnection theory. All the juveniles were asked the same questions regarding the songs, music, or notes that remind them of the most traumatic experience that has happened to them. For example, all juveniles concurred, stating that when they hear again those specific songs, music or notes, it makes them feel very different. For example, the feelings expressed are as follows: angry, sad, afraid, frustrated, ashamed, responsible, dirty, screwed up, and wanting to feel good about themselves, wanting to be accepted by peers/family, and to draw closure to the traumatic memory.

The overall consensus is that MTR did and will alleviate the traumatic experience in all juveniles. The importance of this study not only sheds new light on why juveniles offend, but what makes them offend and gives us the information that is vital for developing a plan to assure that they won't re-offend.

The strength of any program must be the transition program. MTR is essential when developing a program that works.

This author was amazed with the results of this study. This method was created for juveniles, but can be easily adapted for use with adults.

MUSIC THERAPY
RECONNECTION
WORKS!!!!!

Created by Earl S. Lee, M.ED.

Author Location

Created by Earl S. Lee, M.ED., 1500 W. Mead #41, Yakima, WA 98901
Phone (509) 307-4414 or 952-4642 or 452-7253

Qualifications of Earl S. Lee, M.ED.

Graduated from	Yakima Valley College	AA Sociology
	University of Washington	BA History
	Central Washington University	BA Education
	Central Washington University	M.Ed. Master Teacher

Specialization Developing and an Overview of Alternative Schools of Yakima and the United States

	Heritage College presently working on M.Ed. Education Administration	Principal certification

Nominated for Crystal Apple Award twice/Educational Contributor of the Year, Washington State Golden Apple Award

Moral Reconation Therapy Facilitator

Developed an Alternative Program for Gangs, first in Yakima School District (Elite Program)

Featured in *Phi Beta Kappan* magazine

Presented with Les Schwab Committed to Service Award

Started Apex Professional and Personal Services (multi-faceted business for community service) Program Manager/Teacher of five Yakima Alternative Programs-Juvenile Detention Center

School, Stride Program, Elite Program, Key OIC Program, and Stanton Program

Gang Expert

Developed and wrote all curriculum and standards for Apex Private School (Washington State Board of Education approved) Superintendent/Principal/Teacher

Washington State Certified Teacher On Washington State Juvenile Rehabilitation Administration Mental Health Oversight Committee

Mental Health Therapist/Case Manager/Counselor

Developed numerous after school programs/activities for juveniles

Supervisor for after school tutorial programs/mentor

Case Manager, Boot Camp in charge of Mental Health concerns/conflict resolution for juvenile offenders

Trained/Certified in Moral Reconation Therapy, Glasser's Theories, Dealing with Trauma, Anger Management, Conflict Resolution

Wrote two books regarding how to deal with gangs, first in Washington State

Started first gang intervention prevention program for Yakima School District

Short Preview of MTR and Other Methods

PREVIEW

Today there exists a crisis involving juveniles inability to deal effectively with the trauma that exists in their lives, which is probably the number one reason for their actions and choices. There are several tested successful ways for reducing or eliminating the trauma that exists in juvenile's lives. For example, Music Therapy Reconnection (MTR), Eye Movement Desensitization and Reprocessing (EMDRth), Shifting Consciousness Through Dimensions (SCTDth), Integrative Neurological Trauma Resolution, Perceptual Trauma Resolution Methods (NLPth) and Visual Kinesthetic Dissociation (VKD) with visual submodality changes. These approaches all work, but they must be adapted to work for the population that you deal with. That is why this writer created Music Therapy Reconnection. The MTR method works quickly and effectively regarding juveniles.

Music Therapy Reconnection, briefly summarized, takes the participant to the precise music, songs or notes that trigger the trauma, then the juvenile begins to remember the trauma when they hear the music, songs, or notes that they themselves associate with the trauma. The juveniles creates a song, music or notes that enables them to positively deal with the traumatic experience. The juvenile then, using their song, music or notes by (visualization) creates a music video in which they are the star and solving the traumatic experience by being the active problem solver. To check the success of this method, play the music that the juvenile associates with the trauma. Repeat process if the juvenile still experiences any trauma and don't be afraid to change your modalities. For example, have them choose another song, music or notes. The Music Therapy concept has existed for many years, but there has not been a system that has been specifically designed that works as effectively and quickly at alleviating trauma in juveniles as Music Therapy Reconnection (MTR).

SUGGESTIONS

Not being afraid to change the modalities is ok. Juveniles learn differently. For example, technique for developmentally disabled: kids look at pictures, associate music with pictures to initiate remembrances. Ask questions found in Lee Narrowing Technique/Detailed Information About Person's Interpersonal and Social Relationships form. (Counselor, teacher, parent, etc. asks questions.)

Let the juvenile choose the song, music or notes. (Don't suggest or interfere with the juvenile's song, music or note selection in any way.)

Be patient, don't rush the juvenile into picking a selection that is not representative of their trauma experience.

Remember: If a juvenile is dealing with his trauma, do not persist in making them reveal it to you, if they developed their own methods to function appropriately. Leave them alone!!!!

DEFINITION

Modalities: means other methods.

Created by Earl S. Lee, M.ED.

How to Reach the Victims of Crimes Using MTR

Generally, the victim receives much less attention after the act of victimization than the perpetrator. It is my sincere desire to help the victim cope rather than devising new ways to give the perpetrator techniques that will enable themselves to feel better about themselves because of the victimization. Don't mistake my intention, I would welcome a perpetrator who was truly sorry for their actions, but my main focus is seeing victim's lives put back into focus. MTR is that method.

Many professionals throughout history attest to the importance of music in therapy. For example, Anthony Storr is a Fellow of the Royal College of Physicians, a Fellow of the Royal College of Psychiatrists, and a Fellow of the Royal Society of Literature. He is also an Emeritus Fellow of Green College, Oxford and Honorary Consulting Psychiatrist to Oxfordshire Authority. He currently lives in Oxford, England.

Mr. Storr in his book *Music and the Mind (cover page)* states, "Music stimulates the mind, captures the heart and nurtures the soul" (1). On the cover page, Storr notes, "Today, more people listen to music than ever before in the history of the World" (2). He further states that, "In spite of its widespread diffusion, music remains an enigma" (3). He goes on to express the vast importance of music. "Music for those who love it, is so important that to be deprived of it would constitute a cruel and unusual punishment" (4). "Moreover, the perception of music as a central part of life is not confined to professionals or even to gifted amateurs" (5). He further states, "But even listeners who cannot read musical notation and who have never attempted to learn an instrument may be so deeply affected that, for them any day which passes without being seriously involved with music in one way or another is a day wasted" (6).

Try telling your child that they can't listen to their music of choice or try turning it off. Storr state, "Both musicians and lovers of music who are not professionally trained know that great music brings us more than sensuous pleasure, although sensuous pleasure is certainly part of the musical experience"(7). He further suggests that "no culture so far discovered lacks music" (8). "Cave painting bears witness to the antiquity of this form of art" (9) and some of these paintings depict people dancing" (10). "Flutes made of bone found in these caves suggest that they danced to some form of music" (11).

The real exciting part of MTR is, as Storr states, "Since music is closely linked with human emotions, it cannot be regarded as no more than a disembodied system of relationship between sounds" (12). Storr states, "Music has often been compared with mathematics" (13), but as G.H. Hardy pointed out, music can be used to stimulate mass emotion, while mathematics cannot (14). MTR works by using this premise stated by Storr, "Yet music can penetrate the core of our physical being" (15). It can make us weep, or give us intense pleasure (16). Music, like being in love, can temporarily transform our whole existence" (17).

John Blacking, in supposing "that a people's music is one important key to understanding their culture and their relationships" (18). Blacking claims that singing and dancing preceded the development of verbal interchange. "There is evidence that early

human species were able to dance and sing several hundred thousand years before homo sapiens sapiens emerged with capacity for speech as we know it" (19).

David Burrows, who teaches music at New York University, writes. "An unborn child may startle in the womb at the sound of a door slamming shut" (20). The rich warm cacophony of the womb has been recorded. "The mother's heartbeat and breathing are among the earliest indications babies have of the existence of a world beyond their own skin" (21). As with MTR, the belief that music is an essential element being aroused and directed by music is exemplified in this statement by Storr. "Music is said to soothe the savage beast, but it may also powerfully excite it" (22). Storr further states, "what seems certain is that there is a closer relation between hearing and emotional arousal than there is between seeing and emotional arousal" (23). Why else would the makers of moving pictures insist on using music? "We are so used to hearing music throughout a film that a short period of silence has a shock effect; and movie makers sometime use silence as a precursor to some particularly horrific incident" (24). "But a love scene in a film is almost inconceivable without music" (25). "Even in the days of silent films, a pianist had to be hired to intensify and bring out the emotional significance of the different episodes" (26).

Younger children relate very well to their cartoon heroes. During a counseling session, a very young child began telling me that he was this particular cartoon character and how he has all of these special powers that could defeat anyone. As our conversation progressed, he stared to sing the theme song and, in front of me actually transformed into this fictional character. As we talked, he stated that every time he hears the theme song it just gets him all excited, then he transforms into this character. Powerful, huh? This music was the exact tool that I needed to empower this young child to have the strength to deal with his present situation. And it worked.

In my many years working with children, one thing is a constant, their ability for a strong imagination. And in actuality, this is certainly an asset when trying to find out what is traumatic to them and to extinguish it.

Newspapers/Magazine Articles Detail
Music's Impact on Us: What Music Can Tell Us

Resources: Seattle Times, Denver Rocky Mountain News, The Washington Post and the Associated Press: Columbine High Basketball Star Commits Suicide, May 6, 2000.

LITTLETON, Colo. – As a sophomore, Greg Barnes watched girls basketball coach Dave Sanders bleed to death after the murderous attack on Columbine High School. As a junior this year, he became a prime-time basketball guard, leading the team with 26.2 points a game, starring in class and earning adoration from fans.

On Thursday, the 17-year-old Barnes hanged himself in his Colorado home as a CD, set to replay continuously, blared "Adam's Song," by the group Blink 182. The lyrics include the phrases "I never thought I'd die alone" and "I'm too depressed to go on. You'll be sorry when I'm gone."

Fifty-four weeks after the Columbine tragedy, the death of a youth so popular and successful left Jefferson County residents weeping anew and wondering when the scarred community will catch a break. The suicide was the second among friends or relatives of Columbine High victims.

"We were just saying yesterday, 'It's been quiet since the anniversary. We hope we can just finish the rest of the year with no other tremors,' "Jefferson County Schools spokesman Rick Kaufman said yesterday as a fresh wave of grief counselors made their way to the suburban Denver high school.

"I talked to him the night before, and it didn't seem like anything was wrong," teammate Dave Mitchell said. "We talked about the usual stuff, girls."

"I just didn't believe it," said Brian Deidel, a teammate and childhood friend. "It was horrible. It made me mad. Mad at Greg. He had so much going for him. He didn't need to do that to everybody who knows him, who loves him."

Investigators would not say whether Barnes left a note.

Mental-health specialists said they do not know what demons bedeviled Barnes. They hesitated to like his suicide to the events of April 20, 1999, when Dylan Klebold an Eric Harris killed 13 people, wounded 23 more and shot themselves to death.

"It's not necessarily related to Columbine. Suicide is the is the third-leading cause of death for teenagers," said Tom Olbrich, a social worker at the Jefferson Center for Mental Health in nearby Arvada. "It's such a waste. Even if all the other Columbine things hadn't happened, it's still a tragedy."

In the earlier Columbine-related suicide, the mother of Anne Marie Hochhalter, a student paralyzed in the shooting, walked into a pawn shop in October, asked to see a gun, loaded it and shot herself to death. On Valentine's Day, two Columbine sweethearts were shot to death in a sandwich shop.

Barnes, to outsiders, seemed a surprising candidate for despairs. He scored highly in school and even higher on the basketball court.

He had 31 points in Columbine's loss during a state quarterfinal playoff game in March. The Denver Post and the Denver Rocky Mountain New named him to their all-state teams,

and Barnes would have been the top player in the state next year, according to coaches of two opposing teams.

Recruiters from Notre Dame, Harvard and other colleges liked what they heard and saw of the still-growing, 6-foot-3 guard.

"He was obviously in a high class of character and talent," said Vanderbilt assistant coach Tim Jankovich, who had an upbeat talk with Columbine basketball coach Rudy Martin on Thursday, before Barnes' body was discovered.

Martin called him "a tremendous worker and a great student and an outstanding basketball talent," Jankovich said. "I think he mentioned that he could be tough on himself at time, but I don't know many competitors who aren't that way."

Resource: Tri-City Herald by Gary Wolcott, Music, Art Blend Beautifully in "Fantasia 2000", June 16, 2000

Walt Disney believed that as we listen to music, images are formed in our minds, and that it is a total sensory experience, not one that just takes place in the auditory system.

The original *Fantasia,* which was made in 1940, took Disney's hypothesis to another lever. He had his artists make their interpretation of what music would look like if you could actually see it.

To say the idea behind *Fantasia* was brilliant is an understatement. Disney's plan was to have the film be the first in a series of like-minded movies, with a new one to be produced every year. For some reason, he didn't follow through, and it took 60 years for his studio to do a second one.

It was worth the wait.

Fantasia 2000 has been on the gargantuan screens of IMAX theaters around the country for the past few months. When you see it on the screen in a regular movie theater, you're going to kick yourself for not taking the time to go to Seattle, Portland or Spokane to see it in IMAX.

This film is spectacular. It's a visual feast that intertwines sight and sound n the most exquisite ways.

In many areas, the original film is more impressive. Disney's artists had to draw each piece by hand, and the results were stunning.

Most of the artwork in *Fantasia 2000* is computer generated, but it is so beautiful and imaginative that the experience boggles the mind. You're going to be too blown away by the sheer majesty of the new film to make comparisons.

Fantasia 2000 features seven new pieces and a reprise of *The Sorcerer's Apprentice* from the original. Each one is done in a method unique to the music.

Pines of Rome has little to do with pines or Rome. It's a black- and blue-shadowed work that shows a pod of whales frolicking in an ice-bound sea. At times, the whales become airborne, and a star supernovas while they're in flight.

George Gershwin's *Rhapsody in Blue* is a line-based piece set in the frantic doings of a large city.

Pomp and Circumstance normally is associated with people graduating from high school or college. Here, the Disney artists have Donald and Daisy Duck helping Noah load his ark.

Though there is subtle humor throughout all the seven movements, this is the one that is truly funny.

Fantasia 2000 also has flamingos fretting about yo-yos, while *The Steadfast Tin Soldier* combines Hans Christian Anderson and piano concerto from Shostakovich, and butterflylike objects flit through the opening strains Beethoven's *Symphony No. 5*.

Walt Disney introduced stereophonic sound to the motion-picture industry in the original *Fantasia.* Its descendant is state-of-the-art surround sound, and the music will blow you away and bring new height and depth to Disney's concept.

Roy Disney, who is vice chairman of the Walt Disney Company, says in the film's press materials that they are going to fulfill Walt Disney's original dream and release a new *Fantasia 2000* every year.

After seeing *Fantasia 2000,* if Disney's wish comes to fruition, we're in for a cinematic banquet that could last for years.

Resource: Tri-City Herald, b the Associated Press: <u>Celtics' Pierce Stabbed in Boston Night Club</u>. September 26, 2000.

BOSTON – Paul Pierce, an emerging star for the Boston Celtics, was recovering Monday after being stabbed in the face, neck and back at a night club.

He was with several friends when he was attacked during a fight in the pool room of the Buzz Club in the city's theater district. Pierce, 22, was treated at New England Medical Center, police spokeswoman Mariellen Burns said. The hospital would not release information except to say he was in fair condition.

"He's doing fine. We're all hoping for a speedy recovery," coach Rick Pitino said as he left the hospital.

WBZ-TV reported that Pierce had been hit over the head with a bottle and the most of the stab wounds were superficial except for a 7-inch deep cut to his sternum. Several stations reported that teammate Tony Battie was with Pierce at the club early Monday morning.

There was no immediate arrests. Witnesses told police the fight involved security guards connected with the local rap group Made Men, but it was unclear what role Pierce might have played, Burns said.

The attack was the latest blow to a once-mighty team that has faced troubles on and off the court, including seven straight losing seasons and lingering litigation over the 1993 death of captain Reggie Lewis.

Celtics players, coaches and officials visited Pierce throughout the day Monday. His family was en route from California.

"He was very lucky," said K.C. Jones, a former Celtics standout and coach. "He had the angels on his side."

The nightclub will be cited for allowing an attack on its premises, Burns said. She said there have been several other violations there in the past year, including at least two assaults.

Pierce was to report for the start of training camp next Monday. He apparently was in Massachusetts to participate in Red Auerbach's charity golf tournament Monday.

Resource: New York Daily News by David Bianculli: 'Behind the Music' gets good start with Cat Stevens, October 3, 2000.

VH1's Cat show is a Real Winner.

To launch its new season of emotional roller-coaster biographies of famous and/or forgotten musicians, the VH1 series *Behind the Music* begins with the rock music equivalent of *Garbo Speaks!*

That's because, in Sunday's 90-minute special, Cat Stevens talks.

Even at his zenith in the early 1970's, when *Tea for the Tillerman* and *Teaser and the Firecat* fed hit after hit (*Wild World, Father & Son, Peace Train, Morning Has Broken*) to AM radio, the enigmatic Stevens didn't talk much.

He did few interviews, almost no media appearances-just concerts and albums, charting his musical and emotional path as he explored everything from numerology to UFOs.

He makes a terrific *Behind the Music* subject because all his ups and downs came about as a result of either illness and catastrophe or an over-abundance of curiosity.

Born in 1948 as Steven Demetre Georgiou, he ended up changing his name twice: once to Cat Stevens (because, he sheepishly told his manager-to-be, a girl once said he had eyes like a cat), and, after his religious conversion in 1977, to Yusuf Islam (Yusuf being the Arabic spelling of Joseph, a prophet whose story had moved the former pop star).

A few tidbits from the singer's early days are missing, such as the fact that actress Patti D'Arbanville, of *Wiseguy* and *N.Y. Undercover,* was his former girlfriend and the inspiration for his moody early hit *Lady D'Arbanville.*

Most everything major, though, gets touched upon, from the mid-concert walkoff that ended his career to his remarks about Salman Rushdie, which thrust him back into the headlines after decades away from the spotlight.

The final irony, noted by one Stevens friend and colleague toward the end of this documentary, is that the artist formerly known as Cat is busier now than he ever was as a pop star.

Having come full circle to the realization that music is a way to reach people, he now says he'll do anything it takes to connect with the people and get his message out.

And "anything," clearly, includes sitting still to cooperate with *Behind the Music.*

Among other *BTM* subjects this season: Chicago, Sinead O'Connor, Tiffany and Snoop Doggy Dog.

It airs Sunday at 6 p.m.

Resource: by the Associated Press, Oroville Woman Fatally Scalded in Hot Spring Remembered for Spirit, September 26, 2000.

OROVILLE – A 20-year-old who as fatally scalded in a Yellowstone National Park hot spring was remembered Monday as a spirited woman who loved life but was not afraid to die.

Sara Hulphers died about 14 hours after she and two 18-year-old men fell into the 178-degree thermal pool on Aug. 21.

13

Yuvia Storm, 21, said she and Hulphers were having the time of their lives working at Yellowstone for the summer-camping, hiking and making new friends.

"She was so happy," Storm said.

Hulphers had talked about death and the prospect of an afterlife, Storm said.

"She told me...I had to be the one to spread the word she was excited about death," Storm said. "Tell them I had a wonder life-no regrets."

About 300 people filled the Oroville High School auditorium on Monday to pay their respects. The room was decorated with sunflowers and evergreen boughs. A cascade of rainbow-color ribbons was draped over the doorway.

Hulpher's father, Dan, who lives in nearby Molson, sang two songs he had written in his daughter's memory. As he played the guitar and sang softly with two friends, many people sobbed.

A 2-week-old picture of Hulphers at Yellowstone, showing a young woman with a broad smile, dark hair tumbling down her back, her arms wide open and the Rocky Mountains as a backdrop, was printed on the memorial program.

"She said it was the most wonderful experience she'd had in her whole life," Dan Hulphers said in an interview before the service.

"Everyone she worked with liked her. She said she never felt so loved."

Sara Hulphers, a 1998 of Oroville High, was a student at Western Washington University in Bellingham. She was studying science, math and languages.

Hulphers was a straight-A-student and her family just learned a couple of days ago that she had won a new scholarship.

"It was kind of heart-breaking," her father said.

Resource: Yakima Herald Republic, Knight Ridder, <u>Student Guns Down Teacher in Florida</u>, by Martin Merzer, David Green, and Lisa Arthur, May 27, 2000.

LAKE WORTH, Fla.-A 13-year-old boy suspended two hours earlier for tossing a water balloon returned to school Friday, pulled out a .25 caliber Raven semi-automatic pistol, fired once, and killed a popular teacher during the last period of the last day of class before summer break.

The teacher, Barry Grunow, was shot once in the head. He died on the spot, on a breezeway at Lake Worth Community Middle School, with his students just yards away. He was 35. He was married. He had a 5-year-old son and an infant daughter.

Grunow taught seventh-grade English literature and had been a teacher since 1987. He sometimes rewarded his pupils with donuts or funny jokes.

As word of the shooting spread through the low brick building, teachers locked classroom doors. Soon, parents flocked to the school. Former students arrived to share what little they knew, and to comfort each other.

Outside Lake Worth Community, this message-so filled with hope and innocence and joy-was still posted on the marquee: "Have a safe and wonderful summer."

Police identified the shooter as Nathaniel Brazill, a seventh-grader. They said he dashed from the school after the shooting. He ran several blocks north along a pair of railroad tracks. Then, he flagged down a passing police car.

14

"He asked the officer if he had heard about what happened at the school," said Lt. Raychel Houston of the Lake Worth Police Department. "He said he had been involved in what happened."

The boy handed over the pistol and confessed, she said.

"I never though he would do anything like that," said Brazill's grandmother, Eberlina Josey, 74. "He was the best boy. He was good. He stayed home. We gave him the best of everything."

According to the police, Brazill was suspended by another teacher Friday afternoon after he was involved with "some horseplay involving water balloons." He left school at about 1:30 p.m.

A teacher called his mother at work, but was told "let him walk home, I'm at work," Brazill's grandmother said.

The boy, who lives with his mother, knocked on the door of his grandmother's house, the grandmother said. He wanted the key to his own house.

"He looked like he was mad," she said, weeping. "I asked him what was wrong. He said 'gimme the key.'

I said, 'What do you need the key for?'

"He took off out the door."

Brazill went back to the school in the 1300 block of Barnett Drive at around 3:30 p.m. and tried to say goodbye to several girls in Grunow's classroom, Houston said. Grunow stepped out into the open-air walkway and told Brazill to leave.

"Some words exchanged," Houston said. "He fired a single shot, striking Mr. Grunow in the head."

Tom Sloan, whose son Josh Sloan is a eighth-grader at the school, heard that a teacher had been shot when her turned on the television news. He immediately became concerned and headed straight for the school.

"This has been so hard," Josh said, fighting back tear, his face already smudged from crying. "I don't know how anyone will ever be able to trust this place now. It's always been kind of a tough school with some drugs around. There was a fight every day, that's for sure, but that was about the worst that ever happened before this."

Kate McCarthy, a sophomore at The School of the Arts in West Palm Beach, was in Grunow's English literature class two years ago. She and a group of friends relayed the new to one another via pagers and cell phones, quickly gathering near the school Friday.

"His family didn't deserve this. He didn't deserve this," she said. "I am just so angry, and I just want to hear now what they're going to say about gun control because if they say the same (expletive) about three-day waiting periods and if they tell us that things are going to change, I feel like I'm at the point now where I'm going to get up myself and start screaming, Stop this (expletive) and do something. We loved this man and this should not have happened to him."

Resource: Associated Press, Teens shoot each other with the same gun, September, 2000.

NEW ORLEANS-Two teen-age boys shot and wounded each other with the same gun during a fight at their middle school Tuesday after someone slipped the weapon to one of them through a fence, authorities said.

The boys, age 13 and 15, were in critical condition.

Witnesses said the two eighth-graders had argued before the shootings. The younger boy got the gun from someone outside the chain-link fence and shot the 15-year-old, only to have the older boy grab the gun and shoot him, police Lt. Marlon Defillo said.

Students must pass through a metal detector to enter the school.

The younger boy will be charged with attempted murder, Defillo said.

The boy accused of providing the handgun, Alfred Anderson, was arrested about five hours after the shooting at his home in a nearby housing project, part of an economically mixed neighborhood not far from St. Charles Avenue's elegant antebellum mansions

Anderson, who was recently expelled for fighting, was booked on charges of illegally carrying a weapon and being a principal to attempted first-degree murder, Defillo said. He faces a detention hearing today.

The shooting happened just before noon in a breezeway between the main building at Carter G. Woodson Middle School and the cafeteria, where hundreds of students were eating lunch. Police recovered the .38-caliber revolver.

Mike Smith, a 14-year-old seventh-grader, said he heard the shots, and "everybody started running." He added teacher made the students stay inside classrooms until it was safe.

More than 100 parents hurried to the school and lined up outside as officials let small groups enter the building to get their children. One parent said recent violence at the school had made her daughter fearful.

"She was afraid to come to school two weeks ago because boys were fighting," Beronica Lewis said as she hugged her daughter Neshetta, 14, outside the building. "I told her she'd be all right. Now, I'm just afraid for my child."

The school is among modest pastel-colored houses in New Orleans' uptown area, a racially and economically diverse part of town.

There had been several fights reported at the school in the past few weeks, but it was unclear whether the shooting was related to those disputes, said David Bowser, a police spokesman.

Police Chief Richard Pennington said investigators were checking into parents' claims there has been a gang turf battle involving students at the schools.

"We don't think this is gang-related," Pennington said.

Resource: Associated Press, Hip-hop music blamed for Seattle club shootings, September, 2000.

SEATTLE-The mayor, police chief and residents of the Pioneer Square neighborhood say they know what was behind a downtown shootout that left five men wounded early Saturday-hip-hop music and the rowdy crowds it draws.

About 15 shots were fired shortly after 3 a.m. at a park near the Bohemian Backstage nightclub, which puts on hip-hop shows on weekends, witnesses said. One victim remained in critical condition Saturday afternoon.

Police described this shooting as gang-related and an isolated incident.

The Bohemian Backstage's owner did not immediately return a phone message seeking comment Saturday.

Until a few months ago, the club featured primarily Jamaican reggae music, said neighbor Nancy Woodford. When it stared playing more hip-hop-the driving, danceable cousin to rap-the crowds got rowdier, she said.

Area residents said they want the club shut down if it can't control its customers.

Police Chief Gil Kerlikowske said his officers have responded to many incidents at the Bohemian in the past few months, often using pepper-spray to control clubgoers.

Resource: Baltimore Sun, Maryland, Erika Niedowski, <u>Violence Transforms a Young Life</u>, October 7, 1999

The idea for Young Kids Against Violence came last year while Leon; his mother; and his friend DiAngelo Smith-Stokes, 8, a Jeffers Hill third-grader, were in a car. The song, "It's So Hard to Say Goodbye to Yesterday," by Boyz II Men, came on the radio and reminded Leon of the family he had lost to violence:

> How do I say good-bye to what we had?
> The good times that made us laugh
> Outweigh the bad.
> I thought we'd get to see forever
> But forever's gone away
> It's so hard to say good-bye to yesterday.

Leon started sobbing. And, from there, YKAV was born.

How Music Influences Us and How Really Important Music Is in a Juvenile's Life

Let's be realistic, have you ever known kids that don't like music? Music continues to dominate the scene as it has since the beginning of time with angels trumpeting in the beginning of what we know as earth or if you're inclined to believe another version of how we got here. Believe this, you can't think of a stronger drug than music. It makes us laugh, cry, communicate, heal, and remember.

Of the many hundreds of individuals that I've interviewed, all stated that music is vital in their lives. Just think, what if there had never been the Beatles, Elvis, Garth Brooks, Faith Hill, Michael Jackson, Mariah Carey, Backstreet Boys, Brittney Spears, etc. We not only would have missed out on a lot of what is fine music, but a lot of ways we can deal with our problems or communicate how we feel to others. Just think of this, what if that very special song was never written? What would have taken it's place in your life? Can you imagine a wedding, TV program, play, or a production with no music?

Many authors attest to the healing power of music, but you might ask how can music heal me? Well, I'm glad you asked. That's why I created Music Therapy Reconnection. WHEW, this has been one interesting endeavor. Individuals explained to me that when they listen to certain songs, they make them act or feel certain ways. Now that's interesting, isn't it?

I've taken various groups of kids from different ethnic persuasions, status, gender, problems and traumas, put them all together in one large group and taken them through the steps of Music Therapy Reconnection. The results will simply amaze you. All issues were either extinguished or drastically improved in less than ten minutes.

As you can tell, I am really excited about MTR because it is the only program that I've used that really works. I've tested many programs as a teacher, juvenile case manager, therapist, mental health counselor, and music/dance promoter. There is no equal to MTR. This author doesn't know of a system tat is so easy an efficient regarding extinguishing trauma in juveniles, opening up lines of communication between juveniles/adults, locating and extinguishing the problems that are effecting your child painlessly, determining if they are doing things that are detrimental to them. For example, determine if they are contemplating suicide, joining a gang or in a gang, if they have been sexually abused, using drug/alcohol, committing crimes, sexual offender, etc. Music Therapy Reconnection is vital for law enforcement, parole/probation officers, court systems, counseling agencies, school systems, mental health agencies, group homes, juvenile case managers, administrators, lawyers, etc.

Just thing, here is a system that can apprize you of a problem before it happens. I am so confident with Music Therapy Reconnection, that if you have a system that works better than MTR, I would be very surprised and so would you. It was my intention to keep MTR as simplistic as possible so that it would be user friendly for anyone wishing to use it. Now, the good part, so much with the talk. Pick up your Music Therapy Reconnection workbook and see how much easier it will make your life.

Created by Earl S. Lee, M.Ed.

SECTION 2

MTR FORMS

<u>Information Regarding Form</u>
Lee Technique for Narrowing Down when
Trauma Occurred, What the Trauma Is and
How the Trauma Shaped Your Present
Personality

<u>Forms</u>

1. MTR Quick Information Form 1 Preliminary Concerns for Better than General Information (use this form first)

2. MTR Exacting Form for Treatment Plan

3. Additional Information Form (Continuation from Form #2)

4. Specific Information about Persons Interpersonal and Social Relationships and Music

5. Trauma Reduction/Extinguished (form) Using Music Therapy Reconnection (MTR)

6. Music Therapy Reconnection (Assessment Form) for Correlating Your Present Assessment Programs.

Lee Technique for Narrowing Down when Trauma Occurred What the Trauma Is and How the Trauma Shaped Your Present Personality

The first questions asked must be to have the person:

1. Think of their best song when in grade school/group?
2. Their best song when in middle school/group?
3. Their best song while attending high school/group?
4. Their best song presently/group?
5. Their most traumatic song/group?
6. What is the song that best describes you and your life, and why?/group?
7. What song describes the special person in your life and why?/group?

The change in their type of music will show you where the start of their trauma begins. For example, from Whitney Houston to Mettalica or when their personality began to determine whom they are.

Trauma appears in many forms as you well know. Never downplay what a juvenile says is traumatic to them.

The music that a person chooses say a lot about them because they choose it and follow the direction of the lyrics, they live its every word as though they are there and a part of it. It is not a mystical interpretation of the music, it is listening to the words of the songs that they choose as being very important to them. Many people ask me how it is that I am able to know so much about their lives and to be so accurate. I just tell them that people tend to live the lives that they sing about.

When assessing where the trauma or personality change took place, use the elementary-present scale to chart where the trauma or personality change began to take place. For example, look at where the change regarding music selection made its most radical change.

If the juvenile is dealing with the trauma, leave it alone!!!!!!

This method works very well when you need a very reliable assessment quickly.

SPECIAL NOTE: Sometimes you may get a juvenile that doesn't remember the title or exact words to a song, but can remember specifically why they picked specific phrases or particular words that are important to them regarding the specific song. By asking the questions found in the Lee Technique for Narrowing Down (Quick Information) form and Very Exacting Form for Treatment Plan, it won't make any difference if you have to initiate the dialog by use of the aforementioned modalities. The result will be the same. If you require information regarding how the juvenile deals or has dealt with various problems, use The Specific Information About Person's Interpersonal and Social Relationships and Music form. (See forms).

MTR QUICK INFORMATION FORM
JUVENILE RESPONSE FORM

1. What was your best/favorite song when in grade school? /group? _____

2. What was your best/favorite song when in middle school? /group? _____

3. What was your best/favorite song while attending high school? /group? _____

4. What is your best/favorite song presently? /group? _____

5. What is your most traumatic song, the song that brings back bad or painful memories? /group? _____

What is the song that best describes your life and why? /group? _____

What song describes the special person in your life and why? /group? _____

MTR Quick Information Form:
Preliminary Concerns for Better Than General Information
Use this form first

This form is for person asking questions (Students use Form 1A)
(Master Form)

The first question asked must be to have the person:

1. What was your best/favorite song when in grade school/group?

2. What was your best/favorite song when in middle school/group?

3. What was your best/favorite song while attending high school/group?

4. What is your best/favorite song presently/group?

5. What is your most traumatic song, the song that brings back bad or painful memories/group?

What is the song that best describes you and your life and why?/group?

1. Look at where and when music became more diverse. For example: a good indicator of when a person became involved in present activities or hen problems began. Mary had a Little Lamb to Tu Pac. (Tu Pac was an infamous rap star)

2. Ask about the music, don't grill or question song or choice of music. For example: ask person what type of music that they would classify it as.

3. Talk about the music that person chose. Let them explain why they chose it, why it is important to them. Don't be judgmental regarding their response!!!!!!

4. Go down list 1-5. Ask them to explain their choices, but don't demand or judge choices. Listen and write down information that you require to complete your inquiry.

5. If you require more information, use Exacting Form for Treatment Plan or for More Precise Information. (See Form 2)

6. What song describes the special person in your life and why? /group?

MTR Information Form: Very Exacting for Treatment Plan
(Master Form)

Use all of the steps found in the Quick Information Preliminary form with these additions:

1. Listen to the music yourself and take exacting notes because juveniles tend to try and live their music. It impacts them very much. It is how they communicate.

2. Remember: ask about the music, not why the person chose it.

3. Then go down the List of Songs (1-5), asking them about certain words or phrases of the music. Don't help them explain to you what the terminology means. Be calm and wait for a response, don't prod!!!!

4. Remember, it takes about five minutes to listen to a song that will save you many months of wondering what this person is all about that is sitting in front of them.

5. Have juvenile rate on scale of 1-10 regarding accuracy of their response pertaining to their music selection. After you have gathered all the information using their music, ask them if they concur with this information. Then you will have a very accurate starting place regarding what direction you may take when developing a very effective treatment plan.

MTR Additional Information Form
Continuation from Form 2
(Master Form)

1. Tell me why you picked this song and why it is important to you?
 A. Does this song remind you of a very special person or two?
 B. Draw yourself and the most important person to you.

2. Tell me if you feel that this approach works (write)?

3. Rate it on a scale of 1-10, with 10 being the highest rating and 1 being the lowest rating.

4. If during the day or evening a song comes to mind, write the title down. Compile a list of music that makes you feel certain emotions and/or feelings.

5. As client/person if they can remember a saying or phrase that they can associate with their most traumatic experience. For example:

 "I didn't mean to hurt you. Let's play doctor. Let's play a game."
 "I don't want to hurt you. See, you made me do it or hurt you."
 "You remind me of you mother (father). You are a bad person."
 "I'm sad. Can you make me happy?"

6. Are there one or two words in this song that sums up your life presently?

Specific Information About Person's Interpersonal and Social Relationships – Music

1. What is the concern? What song do you listen to that helps you deal with the concern?

2 When does the concern arise?

3. What event takes place regarding the concern?

4. What happens next?

5. Who are the people involved?

6. How do you handle the problem?

7. What are the natural consequences?

8. How do you draw closure to this problem?

THESE QUESTIONS ARE SEQUENTIALLY ORDERED NUMBERS 1-8 AND ALL WORK TOGETHER.

MUSIC THERAPY RECONNECTION
Assessment Form (Client Form)

Present trauma: What is it?

Past trauma: Is it still a concern?

Then go on to:

Present sleep problems?

Past sleep problems?

Any songs that help you deal with problems?/group

Trauma Reduction/Extinguished
Using Music Therapy Reconnection (MTR)
Checklist Form

Juvenile	Trauma	Result (E/N)
1		
2		
3		
4		
5		
6		
7		
8		
9		
10		
11		
12		

Results: E-Extinguished N=No

Music Therapy Reconnection
Assessment Form (Master Form)

This is the most efficient and honest assessment that you will ever need. This form can be used with SRA, DMHS, MAYSI, and MTR Forms 1A-4 or alone.

1) PRESENT: Trauma. What is it? Refer to songs, lines, or phrases. This is probably the most difficult area for them to openly talk about. This is the most feeling self, their fear, you are not sincere or caring enough.

 PAST: Trauma. Is it still a concern? (If they have dealt with it, don't reopen problem.

2) PRESENT: Sleep problems, refer to song, lines or phrases of song. This is when they will tell you about their dreams and most certainly why they don't sleep.

 PAST: Did you have sleep problems?

3) PRESENT: Thoughts of suicide. Why? Refer this why answer to song that they gave you and talk about the lines, phases in their song. Quick answer here generally, but don't accept it too quickly.

 PAST: Usage of substance abuse. Did you receive treatment? Inpatient or outpatient? What treatment was most effective for you. Was anyone in your family a user? Did anyone that you know have dire consequences from their substance abuse? For example, die. What was your substance of choice?

4) PRESENT: Drug/alcohol use. Any treatment? Refer to lines, phrases in son. Substance of choice? What does it do to you? When do you do it? For example, how do you function? Easiest area to talk about more support and understanding here than any area because you both know of treatment modalities and that you both are literate and knowledgeable enough to talk about.

 PAST: How did you view yourself?

5) How do you view yourself presently? (Happy, sad, smart, indifferent, dumb). Refer to lines or phrases of song to help with this answer. This is the reasoning area. Now they have to justify their responses.

Presently, how do you deal with anger and conflict? Refer to line, phases of song. This area will be them telling you something like this: "I get angry because…" and how "they" deal with it.

PAST: How did you deal with anger and conflict?

Presently, do you think things through before you do it? Refer to lines, phrases of song. Here is when issues (a lot of thought goes into this area even if they answer quickly, your time to delve).

PAST: Did you think things through before you did it?

Presently: Would you hurt yourself physically or mentally (thoughts).

PAST: Would you hurt yourself in any way?

Presently: Do you care about other's feelings or just yourself? Refer to lines, phrases of song. Here they will talk about either why they don't care about others and experiences.

PAST: Did you care about others feelings?

Presently: Would you consider yourself an exciting person? Refer to lines, phrases of song. They will talk about what they like to do.

PAST: Did you consider yourself an exciting person?

Presently: Are you a risk taker? Refer to lines or phrases of song. They will talk about experiences that they had.

PAST: In the past were you a risk taker?

Presently: Do you love your family? Refer to lines, phrases of song. They will single out a person in their family (Mom, generally).

PAST: Did you love your family?

Presently: Whom do you love most in this world? Refer to lines, phrases of song. Here kids feel challenge and either will say myself or number on one answer, Mom. Sometimes a girlfriend/boyfriend enters the picture.

PAST: Whom did you love most in this world?

Presently: Do you like to dance or sing? This is what I call the landing stage (where they come down from that feeling area, but not too abruptly. This area takes them back to memories of.

PAST: Did you like to dance and sing?

Presently: What is your best food? Memories of people, friends, and gatherings.

PAST: What was your best food?

Presently: What is your best video game? Memories of control, being good at something.

PAST: What was your best video game?

What I am doing regarding this assessment is making the subject feel safe and in control of making his/her responses without pressure, by using the receding of the objective mind (sensory, awake self) to bring to the fore the subjective mind. This is actually our asleep/memories state of mind. During this exercise, the subject seesaws back and forth between the objective mind (which is your awake state of mind). I've noticed that through practice that Hypermensia (increased recall ability), is best achieved when the before mentioned techniques is used. My objective is to create the conditions that enable the subject even after the assessment for the subject to be able to talk freely and openly about anything.

Special note: Generally most questions can be answered by using form 1A MTR Quick Information Form; Juvenile Response Form Numbers 4-5, and what is the song that best describes your life, Why? 1-3 is to give you early information regarding when the trauma occurred and if, in fact, it occurred early on. Remember, trauma is probably the number one reason why juveniles are having their present troubles.

Additionally, if you honestly and objectively look at the assessments used to day, how much of that information is actually used in a transition plan? Isn't it redundant information? That during a person's stay at any given facility, the information stays the same upon arrival and transition? I think it is human nature to view the voluminous reporting as the best, but isn't it also true that 911 works better because it is fast, effective, and efficient?

The Music Therapy Reconnection assessment gives you honest, accurate facts and efficient information that you will have within minutes. MTR goes deeper into the client's inner self than any assessment to date, yet remaining non-threatening and very effective.

SECTION 3

Samples of Neurological and Perceptual Method for Quickly and Effectively Extinguishing Traumas in Juveniles

A sample of a neurological and perceptual method for quickly and painlessly effectively extinguishing trauma in juveniles/Music Therapy Reconnection.

Music Therapy

1 Test – Students by having them listen to notes to see which notes by a show of hands are more relaxing or which songs or music is most relaxing.

2 Ask all students to remember a traumatic experience while playing the relaxing comforting music, notes, and songs.

3 Then ask them to remember the traumatic experience and a song, music, or notes that brings this memory to mind. Ask them to visualize themselves being in that song or music video, responding to the music being an active participant, living it. Then solving or drawing closure to the experience by actively being able to participate in the solution while in the music video.

4 Ask the students to tell you if they are experiencing more, less, or no memory of the traumatic experience.

5 Repeat process if any individual is still having memories of the traumatic experience. If so, repeat process or modalities. For example: use new music, notes, or songs. (Do as many times as necessary, generally it works the first time.)

6 Juveniles respond better to visualizations with music or a beat that is comforting and representative of the youth's experiences.

7 Check results of the procedure by having the students try and visualize the traumatic experience. Use songs, music and notes to initiate the revisiting of the traumatic experience. Check to see if they still have the traumatic response. Repeat procedure if they are still experiencing trauma.

8 Have them pick a new song, create a positive rap song, then have them sing it and hum it daily. Repetition is very important, continually reproduce the positive.

9 Have them write a positive son about themselves or a very positive experience in their lives and keep a daily journal highlighting the positive.

10 If the juvenile is dealing with the trauma, leave it alone. There is no need to revisit a traumatic experience that they have dealt with.

For use with all juveniles experiencing trauma: Incarcerated Youth, Adjudicated Youth, At Risk Youth, Gangs, and Special Needs Youth. The techniques that are incorporated into this program are proven to be very successful methods for painlessly resolving trauma quickly.

Dealing with the Mentally Ill Using Music Therapy Reconnection

There are those times when a client is more receptive. It is such times that you use Music Therapy Reconnection. Having worked with mentally ill clients for many years, music has a calming effect on the mentally ill whether they are humming or singing that special song. Whether it makes sense to us or not, they have the presence of mind to remember the rhythm, words, phrases, or song. Many people pass this off as anxiety, behavior disorder, compulsion ritual, coping mechanism, delirium, euphoria, malingering, manic episode, psychosis, schizophrenia, or more of the above and say they are just crazy.

I remember Christmas time when I was very young. We would sing Christmas songs, reciting our Christmas poems and sing more Christmas songs. When I think back over those times, certain music jogs my memory. And whether I am there physically or mentally, I am there and a very vivid picture I see. It is very important that we realize that. Isn't there a possibility that the mentally ill see too?

Many professionals view the mentally ill behavior as a diagnosis. I see it as a reaching out, whether disorganized or not-it is their reality. Many times when behavior escalated to the point where most therapists or mental health professionals would say medicate, I liked the musical approach. In most cases music worked. It is not my contention to down or say never medicate. I'm just saying you should try music also. For example, try a sampling of childhood songs, the national anthem, holiday songs, school songs, classical, and present/past-day music. You will be surprised with the results.

(1) When a person acts out, there is something wrong, right?

(2) When they act out, they need something that will calm them down, right?

(3) Music works, just try it.

This is my technique for soothing the soul with Music Therapy Reconnection:

(1) The person needs to be in a quiet place, Unrestrained music should be piped into this special area.

(2) Music should be played in combination, beginning with childhood songs, then holiday songs, the national anthem, school songs, classical (Mozart preferably), and a collection of present/past day soft listening music. This order is very important.

(3) You will visually see them change before your eyes. They will become calm. In most cases they will be very emotional. During some songs they will start singing along and you will be able to communicate with them.

(4) Once I get the person to calm down, I can pick out the songs and music that visually had the greatest calming effect. I then play that music and take them through the Music Therapy Reconnection process.

(5) My objective is to get this person to bring forth the subjective mind (memories), while the objective mind of sensory recedes.

How to Effectively Deal with the Developmentally Delayed and Disabled with Music Therapy Reconnection

(1) Music with pictures created in the mind brings back memories. First you may have to show your clients pictures with a very soft tune playing in the background to jog the memory.

(2) If you use physical pictures, ask the client about these pictures. Then ask them to try and relate these pictures to a time in their lives and music that they liked or listened to during that time.

(3) Listen to which words and phrases of the song that they remember. It doesn't have to be in order.

(4) Pick out the words and phrases of the songs that mean something to them.

(5) Create your list of questions from those words or phrases, but only ask questions about the words or phrases of the music. Don't be judgmental.

(6) This interaction will give you a better understanding of your clients and enable you to communicate better with them. They will, in turn, feel more comfortable being around you.

Opening Up Lines of Communication with MTR

We continually ask ourselves, "Why do our children act the way they do? Why can't we talk anymore? Why don't we get along? Why does my child disrespect me?" The answer to those questions are simple, because you don't communicate anymore. You don't know how to talk to your child. Your world has evolved and so has your child's, but you just don't know how to reach their world and they, likewise, can't connect with yours. So you say things like this to your child, "You have totally changed. You're not the same person that I used to know." You then expect your child to accept the critique of themselves with no comment.

You find yourself and your child growing farther apart, because you don't know how to communicate with each other. At this point, you need desperately to develop lines of communication. Don't just walk away, because your child will surely find someone whom they *can* communicate with and thus, the problem will compound. Let's back up to when you wanted to talk to your child.

1. Start with a positive statement or interest and relate it to something that you both know something about. For example, music.

2. Don't judge their music, but they will most certainly judge yours. Don't argue!!!!!!

3. Ask them about what the words, phrases, and intent of the music is. For example, say "What type of music is this?" It is very important, don't be judgmental.

4. Say something positive about the music, phrases or words. This is very critical time for you to open up the lines of communication.

5. Move to the rhythm of the music, move your head. This may really dumbfound your child. This non-verbal communication is not setting up an adversarial situation, but one of objectivity.

6. Establish eye contact with your child, continue to nod your head and they will become more relaxed and begin to nod their head in unison.

7. Your child is beginning to feel more comfortable. You may not be, but remember, you want to start communicating more openly with the child.

8. Even if this is the worst music selection that you have ever heard, keep a smile on your face. Remember, your key objective is to open lines of communication with your child so, as the old adage goes, grin and bear it.

9. This next step is probably the toughest part. You have to ask to listen to more of their music. What happens next is that in their minds you are, all of a sudden, starting to become "a pretty cool person," not just a dinosaur of the past.

10. It is very important that you make no judgments regarding their music because in that music, the words and phrases will open the lines of communication between you and your child. "Music is a…heaven-sent ally in reducing to order and harmony and disharmony in the revolutions within us" (1). #Plato, Timaeus and Critias, Desmond Lee, Trans.

Sexually Abused Children: Helping Them Open Up When Age or Competency is at Issue

Generally when a child is too young to disclose what took place with them sexually, it is very difficult to establish that fact and a competency test is required. Another barrier to establishing what happened regarding the young child is their age. They generally cannot pass the competency test to establish themselves as a competent witness, to relay the truth or facts regarding what really happened to them. In addition, victims of sexual assault act complacent, have a flat affect, are hyper vigilant, watching every move that you make. They are sleep disturbed and have nightmares of strangers chasing them as well as trauma because they couldn't deal with the problem.

They start acting differently. For example, touching themselves or an over emphasis regarding their sexuality. The common offenders are as follows: father, step father, brother, grandfather, and cousins. Children generally keep what is happening a secret. What appears to make the child tell on the perpetrator is vaginal or anal penetration. The victims just don't know what is going to happen if the victimization continues. If the victimization/abuse is taking place at home by a father, step father or brother or if the offense took place in a bed where the child sleeps, they can't sleep.

For the child that receives the opportunity for therapy, during the sessions some additional affective behaviors might be that the child is outraged. During play therapy, they pick stuffed animals to vent their rage on. They stomp and throw animals around the room. A safe environment must be created in the home.

How to deal with this problem was really a tough concept until I created Music Therapy Reconnection. One man had committed over twenty different sadistic, brutal sexual abuses of children. To date, there has been no prosecution nor adjudication as stated by a children's trauma specialist at a workshop training, because of the age of the child and competency test. Kids don't have the language to describe what is going on.

Another problem is if a child is abused long enough, the abuse will seem normal. Kids don't want to tell about sexual experiences. They don't open up. What is really sad to me is that there have been very few methods available to children that help with this very severe problem of how to deal with children who have been sexually abused.

Music Therapy Reconnection is very effective method for dealing with such a problem. I intentionally only talked about the victims of sexual abuse, because it is this author's belief that there are too few programs for the victims. Music Therapy Reconnection is also very effective regarding the sexual offender.

Technique Using Music Therapy Reconnection with the Very Young Child Just like play therapy, you want the child to open up, feel emotions, recall, and extinguish the trauma. You want the child to feel safe and blameless for the actions of others perpetrated against them. Unlike play therapy, you want the child to open up, feel emotions, recall, and extinguish the trauma. You want the child to feel safe and blameless for the actions of others perpetrated against them. Unlike play therapy, during Music Therapy Reconnection the objective is

(1) Aimed at exposing the perpetrator, letting them know that the child will be able to express in words, confidently and factually, what has been happening to them. That is the perpetrator's main fear.

(2) Say the names of the people or person involved.

(3) Feel blameless for the resulting abuse.

(4) Extinguish the trauma associated with the act.

(5) Develop a sense of high esteem, self image, and self worth.

(6) Develop the ability to communicate thoughts.

(7) Develop the ability to cope with tragedy.

Music Therapy Reconnection Technique for the Young Child Who Has Been Severely Abused

Kids have their special music/tunes or songs that they like. For example, Barney, Disney songs, Pokemon songs, Dragon songs, Ice Man songs, Back Street Boys, Brittney Spears, Garth Brooks, or another favorite group. You see, they need a mode of expression, identification, release, an a safe haven - a way to communicate their concerns.

Technique

(1) Ask children what kinds of songs/music or cartoon characters they like. Be patient.

(2) Ask them what they like about the music. For example, "Does it remind you of any special event or happening in your life?"

(3) Give examples of what you would like to know. For example say does a certain music remind you of when you were very young or now? Then, quickly change the subject before they can answer. What you want to happen is for the objective mind of the subject to recede and the subjective mind to come to the fore. The objective mind is capable of inductive and deductive reasoning, the subjective mind is capable of deductive reasoning only. With the objective mind, generalizations arrived at given particulars. For example, a doctor looking at symptoms of chicken pox (high temperature, bumps, cough, etc.). These before-mentioned particulars lead to the generalization that yes, he/she has chicken pox. The subjective mind is capable of only deductive reasoning. For example, when given a generalization, one infers the particulars-a person must have chicken pox if they doctor says he/she has the symptoms. The doctor tells the mother and the mother gives the doctor's information to the teacher. The teacher may then deduce the particulars. For example, that the child has a high temperature, a rash on the body with small lesions. Two minds are ever present in each individual, in a relative state of see-saw balance. This two minds theory is the premise that hypnotists work under. The objective mind, your awake self, control your senses. The subjective mind controls memory while you are asleep or in a trance or having memories. That is why it is important to change the subject quickly after asking, "Does it remind you of when you were very young or now?" Because the subject will open up to you on demand and try to remember even if the person doesn't want to, because they are using the objective and subjective mind at this point. They will appear frustrated and generally ask you why you didn't wait for them to answer your question. This is my technique for how I cause a conflict in the objective and subjective. Sexually abused or not, most kids like to talk and want to have their opinion heard. When I give in and concur with the subject, it makes them more open to my request, because they think that I am really no too concerned or interested in knowing their deepest secrets.

48

(4) As we start to talk about their music, not their concerns, they start to give me vital information about what their music or songs mean to them and why they chose them. This occurs without much prodding from me except to ask questions about the phrases or words of the songs. At this point, have them visualize themselves being in the song, in a music video, or being an active participant solving the trauma by being in total control over their situation.

(5) The final step. Now they are to visualize themselves happy, laughing, feeling safe, in control, and having solved the problem. Accentuate the positive. Draw and color happy pictures, having fun, being in a safe environment. Draw your school, teacher, a police officer, car or police station, counselor, all the people that make you feel happy (a collage). Hang that picture in a very conspicuous place for al to see. Also tell the child to draw other pictures anytime they feel sad, sing or hum a happy song daily or create a song that tells how you are feeling. Even if they can't make up the rhythm, it is the words you want to see.

Why Religion and Music Therapy Reconnection Work So Well Together
"Make a joyful noise unto the Lord"

Throughout early religion, singing and music go hand in hand. Many of the religions of today use music as an integral part of the service. Singing from their hymnals, songs that they grew up singing, and their relatives before them. Music and song that may have been buried in the subconscious state until they hear it again or star singing it themselves, this music conjures up remembrances, times of family closeness, feelings people and events. As I sat in church the old song "Amazing Grace" was being sung. Many memories came to mind and emotions. I don't know of anything that will make you feel deep emotions faster than the favorite music of that person who has passed on. The music of religion transcends all age barriers, everyone sings openly regardless of the age of the song. You could say the music brings us into a totality of one-ness.

Even before the service actually begins, music opens the emotions and sets the mood for the message. It is this author's profound belief that music was with us form the very beginning in one form or another. Do you ever look around the church at the faces of the people? They appear to be very focused and serene. Music Therapy Reconnection works because it encompasses all music and any music that will cause the listener to remember.

When I used to sing in the choir, that was my time to showcase my talent and watch how the listeners responded. It was really exciting to see people become very excited and comment to the Lord regarding our signing as though He was right there. I've always had a very special attachment to music. It is very mystical, it can make you feel good and bad, but never indifferent. Something happens inside of us no matter how hard we try to retard the coming forth of those feelings. Music Therapy Reconnection gives each person through their music the opportunity to revisit time past and to see with vivid detail events that actually took place many years ago, revitalizing those same feelings as though they were happening at the present moment. When I want to see my grandfather, who has passed away many years ago, I just start singing Amazing Grace, and there he is, back in that small church on 6th Street, smiling and saying, "Don't you dare go to sleep in church."

How to Deal with Gangs Using Music Therapy Reconnection Forms 1A, 2, 3, and 4

Determining if a person is in a gang is not difficult using Music Therapy Reconnection.

Traditional methods almost always fall short. Also ask about visible tattoos, ask if it relates to music choice.

1) Gang members are very proud of their music and they will without reservation tell you what it is.

2) Gang members music will also tell you what gang they are in.

3) Gang members music will tell you what they like to do. For example, drive-bys.

4) Gang members music will also tell you who they hate and who they would like to see dead.

5) Gang members music will tell you what they have done recently.

6) Gang members music will tell you who is the most important person in their lives.

7) Gang members music will tell you their greatest fears/joys.

8) Gang members music will tell you who they are planning to hurt next, why, and who they hurt in the past.

9) Gang members music will tell you their plans before they carry them out.

The Importance of Music Therapy Reconnection in Therapy

Our outer world reflects our world within. The conditions around us reflect how we feel about ourselves.

Every one of us is born with music within us if you can believe that genetically we are predisposed to anything, then why not rhythm, music? Try listening to a song that you like. Does your brain tell you what to do? How to react to the sounds? Yes, but how does it know? "The isle is full of noises, sounds, and sweet airs, that give delight and hurt not, sometimes a thousand twanging instruments will hum about mine ears, and sometimes voices that, if I then had waked after sleep, will make me sleep again."

In the late 60's, a group of people got together and started a little theater group. Kids from the community got the opportunity to try out for parts in this group. The main emphasis was to develop unity between the races. The format of the show consisted of full-blown plays to dance acts. The shows were very instrumental regarding who I am today. Amidst all the racial hatred and strife, here was a group using song and dance to promote unity.

In the early 80's, I started using music/song/dance as a focal point for turning young kids lives around. I put on the Central Washington Talent Show, the Pacific Northwest Talent Shows and "WOW". What a success at bringing people from both sides of the tracks together. For example, we had the rich, poor, minorities, all working and competing through music and dance. Some of the kids that won first place went on to sing to the White House for the President. Some stated that they had never been so excited with the opportunity to open up and showcase their talents.

Out of these talent shows, a lifelong bond was established with six young break dancing boys (The Central City Breakers). These boys became so dedicated to being somebody that they would meet daily in a filthy dirt floored garage with a piece of cardboard and dance to the music, creating music and harmony. I would meet with these boys, taking them to events, schools, and community affairs all over the state so that they could perform and spread the joy of the music and dance.

If you remember break dancing, it is "back now," consisting of spinning, flares, gyros, helicopter, centipede, and the spider. The break dancing era became so big that the Capitol Theater wanted to put on a Pacific Northwest Break Dancing Contest. So we did, and it was a huge success. People from everywhere were there. The theater became alive, with people jumping up from their seats, dancing, singing, and seeing the acts that had been custom made for this show. This was the boys night to show what handiwork and dedication can do for you. To make a long story short, The Central City Breakers won first place and many public ceremonies and events were to follow. I would like to say that the boys lived happily ever after, but they didn't. If only I had known then what I know now regarding the power of Music Therapy Reconnection, I could have helped direct these boys to success instead of

sporadic success and mostly failures. You see, I had these boys when everything important to them was music. Like the kids of today, music is how they communicated. If I would have seen the warning signs and corrected them, things would have been different.

I am going to use the example of one of the boys to show you how easy it would have been to help change his future. One music is the hook and what the music says is how he felt and acted. This young boy was from an African American single parent family with a welfare mom and several other children. He had little education, lived in a shack with cockroaches everywhere and where they weren't, cats were.

This young man, even after all the fame he had received, still had to face the reality that he had to go home to a very depressing reality. Although the kids stopped teasing him as much because of his fame. His brothers and sisters didn't receive that same respect, so that made it his problem. The mother would walk to town unkempt and it would deeply hurt him when people would comment on her.

What I know now is that it was his music that enabled him to tolerate his deplorable situation. When he was dancing, he was in the world created by the music. He could escape the reality of his present situation, because the music put him in another situation. Remember, we create our own reality and live it.

If I would have listened to his music, I would easily have known where he was, what he was thinking, and the direction that he was heading. His musical world was his safe haven. That is why his selection of songs, and of course, his dance songs. But? Jim Croce's *Time in a Bottle*, Operator Bill Withers' *Lean on Me, Ain't No Sunshine*, Stevie Wonder's *For Once in My Life*.

When I listened to a verse of that song recently, I cried.

> *For once in my life, I won't let sorrow hurt me,*
> *Not like it hurt me before.*
> *For once, I have something I know won't desert me,*
> *I'm not alone any more.*

I haven't seen this young man for many years, but read about him in a local newspaper. He is in prison and probably really always was, because we didn't have the key until now, to open his door to a different direction in life. With Music Therapy Reconnection, we can get into the innermost depths of the person to explore and determine what solutions can be offered for a more functional and purposeful life.

By using MTR, we can outline a clear-cut direction that, if followed, will insure a greater amount of success. MTR can quell the pain within the inner self and revitalize the spirit of the individual so that every option for success doesn't end up on the heap of life's untried throw always.

MTR will allow you to let go of unresolved anger, let go of preconceived misconceptions about self. It will allow you to stop blaming yourself for actions perpetrated against you, get rid of self defeating, self destructive thought. You can let go of feelings of guilt, help determine your thrive potential, and stop blaming others for your shortcomings. MTR can enable you to associate more openly with others, create a feeling of self worth/self esteem. It gives you a definite direction regarding where your life is heading, clear out your mind of thoughts that lead to negative thoughts of yourself, and purge your mind of thoughts that deluded your self worth.

When taking a person through the Music Therapy sequence, as stated in Section 3 of this book, it is very important to let the music that the person chose relax them. Don't try to have them practice breathing techniques, that will come naturally as they become relaxed by their music. Our objective is to have them think only about their music.

SECTION 4

Correlating Music Therapy to Work with Your Present Assessment Program

Correlating music therapy to work with your present assessment program is very simple (see form in Section 2)

(1) It doesn't make any difference what you are trying to ascertain about your client. Simply ask the questions you need to know and have them address that specific phrase found in their song. For example, if you want to know if they are doing drugs, ask about the phrases in the song that address that issue.

(2) The Massachusetts Youth Screening Instrument (MAYSI) is a 52-item mental health screening tool designed and normed for use with juvenile offenders in custody. The MAYSI has nine MAYSI sub-scales which, after answering the 52-items determines how many areas of concern there are or how many red flags you have or which sub-scales were in the red flag range. The nine sub-scales are as follows: 1) anger, 2) anxiety, 3) thought, 4) somatic, 5) drugs, 6) suicide, 7) trauma, 8) depression, 9) impulse. Music Therapy Reconnection will tell you precisely what the problems are by having the client address the phrases in the song that relate to the sub-scale. After going through the Music Therapy Reconnection process, asking about the most favorite or best song in grade school – What is the song that best describes your life and why? You will have the answer to all of your 9 sub-scales and areas of concern will be defined.

(3) The Suicide Risk Assessment really could be completed from the MTR and MAYSI information, because if you complete the MAYSI and Music Therapy Reconnection, you can use the information gleaned from that to easily fill in the Suicide Risk Assessment (SRA) and it will be more accurate or you could just use the information from Music Therapy Reconnection.

(4) Diagnostic Mental Health Screen. When correlating this with Music Therapy Reconnection, MTR will make this assessment more effective because the client using MTR will define and relate the information to actual experiences that have happened in their lives. In essence, you will get more honest and complete answers regarding the eight areas of concern: 1) treatment history, 2) depression, 3) suicide/self-mutilation, 4) anxiety/thought content, 5) attention/concentration, 6) medication, 7) drug/alcohol, and 8) detention behavior/mental status.

(5) Music Therapy can also be used as a standalone assessment devising questions for areas that you need answers to immediately.

(6) Remember, in the juvenile's life "music" is extremely important. It establishes their peer group, how they communicate, how they say I love you, how they develop emotionally and physically.

SECTION 5

Regarding the Juveniles responses, no spelling was corrected regarding their sequential problem-solving responses.

Study Results from Music Therapy Reconnection

These juvenile's results were randomly selected. When I gave them the Lee Narrowing handout, it took them five minutes to complete it. The information that was amassed as a result of this information was vital for putting together a treatment plan that really works. The information retrieved from the study was accurate, reliable information that, without Music Therapy Reconnection (MTR), could have been overlooked forever or for many months.

The MTR system works faster, better, and with results that will amaze you. The clients will open up to you without even knowing it. They will be more honest with you from your first meeting, because their music will tell you how they think and feel. I have worked with numerous programs and have found none to compare or even come close to this program. Parents will immediately know what their children are thinking and feeling. Parole, probation, school officials, counselors, JRA staff, teachers, administrators, police officers, lawyers, judges, and anyone needing to be privy to information quickly, will have it.

If you have a Moral Reconation program in place, MTR will supplement that program extremely well. All participants agreed on a scale of 1-10 regarding accuracy and did not present any intimidation. For example, they stated that it is the best program that they ever used.

Specific Information About Persons Interpersonal And Social Relationships. Detailed Information About Persons Interpersonal And Social Relationships and Music.

1. What is the problem?

I keep getting locked up.

What song do you listen to that helps youdeal with the concern? <u>Driving with My Homies</u>

2. When does the concern arise?

Whenever I am driving.

3. What events take place regarding the concern?

I speed, then I get pulled over by the police.

4. What happens next?

I wait until the officer is next to my window then I speed off to get away.

5. Who are the people involved?

Me, the police, and anybody around me at the time.

6. How do you handle the problem?

I try to escape by driving at high speeds and run away from the police.

7. What are the natural consequences?

I go to jail for as long as the Judge gives me.

8. How do you draw closure to this problem?

Stop driving until I can get a driver's licsense.

 THESE QUESTIONS ARE SEQUENTIALLY ORDERED NUMBERS 1-8 AND ALL
WORK TOGETHER.

<div align="right">Created By Earl S. Lee M.Ed.</div>

Specific Information About Persons Interpersonal And Social Relationships. Detailed Information About Persons Interpersonal And Social Relationships and Music.

1. What is the problem? What song do you listen to that helps you deal with the concern? <u>Driving in My Benz</u>

I am having a driving problem. It seems like every time I get behind a steering wheel I get arrested. What will I do if I want to get a hyster or forklift job.

2. When does the concern arise?

I always get in trouble while driving.

3. What events take place regarding the concern?

Every time I am having a pretty good time I get pulled over. (Or at least close to.)

4. What happens next?

I wait for the police officer stops then I step on the gas and elude.

5. Who are the people involved?

All the time I am alone when I elude the police.

6. How do you handle the problem?

Either I go to jail, (boot camp), or I can just stop driving until I get a driver's licsense.

7. What are the natural consequences?

I would and will get locked up and I will possibly injure myself, my car, and other people and their property.

8. How do you draw closure to this problem?

I stop driving until I can get a driver's licsense and until I gain <u>Responsibility!!!</u> I will gain <u>Responsibility!</u>

 THESE QUESTIONS ARE SEQUENTIALLY ORDERED NUMBERS 1-8 AND ALL
WORK TOGETHER.

 Created By Earl S. Lee M.Ed.

Specific Information About Persons Interpersonal And Social Relationships. Detailed Information About Persons Interpersonal an Social Relationships and Music.

1. What is the concern? What song do you listen to that helps you deal with the concern? 50 "G" Contract

My problem is not being able to find a job.

2. When does the concern arise?

I need MONEY to live. I had none so I had to steal to get it

3. What events take place regarding the concern?

I get I trubol with the law

4. What happens next?

I end up in the same place as I was in before

5. Who are the people involved?

Friends

6. How do you handle the problem?

Get a job and stop hanging around with thoughs kinds of people

7. What is the natural consequences?

I get in truble with the law

8. How do you draw closure to this problem?

Get a job and help to stop stilling

 THESE QUESTIONS ARE SEQUENTIALLY ORDERED NUMBERS 1-8 AND ALL WORK TOGETHER.

Created By Earl S. Lee M.Ed.

Specific Information About Persons Interpersonal And Social Relationships. Detailed Information About Persons Interpersonal And Social Relationships and Music.

1. What is the concern?

Stepdad

What song do you listen to that helps you deal with the concern? Fade to Black

2. When does the concern arise?

At home and other places

3. What events take place regarding the concern?

A lot of yelling, cursing, sometimes pushing

4. What happens next?

Yell back, leave the house. Curse etc.

5. Who are the people involved?

Family

6. How do you handle the problem?

Run away, stole his things, curse at him

7. What are the natural consequences?

Were all going to pay

8. How do you draw closure to this problem?

Try to talk it out, work together. Here.

 THESE QUESTIONS ARE SEQUENTIALLY ORDERED NUMBERS 1-8 AND ALL WORK TOGETHER.

<div align="right">Created By Earl S. Lee M.Ed.</div>

Specific Information About Persons Interpersonal And Social Relationships. Detailed Information About Persons Interpersonal And Social Relationships and Music

1. What is the concern? What song do you listen to that helps you deal with the concern? <u>It's a "G" Thang</u>

Burglarizing houses

2. When does the concern arise?

When I'm high or drunk and have no money or I need money

3. What events take place regarding the concern?

I look at a house and think I need money why not rob that house.

4. What happens next?

I go in through a window or door.

5. Who are the people involved?

Me and my friends.

6. How do you handle the problem?

I sell the equipment and get money for them.

7. What are the natural consequences?

Going to jail.

8. How do you draw closure to this problem?

Drug and Alcohol treatment.

THESE QUESTIONS ARE SEQUENTIALLY ORDERED NUMBERS 1-8 AND ALL WORK TOGETHER.

Created By Earl S. Lee M.Ed.

Specific Information About Person Interpersonal And Social Relationships. Detailed Information About Persons Interpersonal And Social Relationships and Music

1. What is the concern? What song do you listen to that helps you deal with the concern? <u>Hotel California</u>

Lack of Self Control

2. When does the concern arise?

Everyday. I would do what I considered (fun) and not what was good for me regardless of the help I had to change my attitude

3. What events take place regarding the concern?

I would use drugs & alcohol, I would go on the run to hang out with my friends. I would continuously get locked up.

4. What happens next?

I would get locked up and put more stress and anguish on my family and make it worse for my future.

5. Who are the people involved?

Myself, my family, my PO, my friends.

6. How do you handle the problem?

I came her to give myself more self-control.

7. What are the natural consequences?

I get into trouble and hurt my family with my family.

8. How do you draw closure to this problem?

Take the skills I learn here and use them at Job Corp, and use them in my daily life from here on out.

THESE QUESTIONS ARE SEQUENTIALLY ORDERED NUMBERS 1-8 AND ALL WORK TOGETHER.

Created By Earl S. Lee. M.Ed.

Specific Information About Persons Interpersonal And Social Relationships. Detailed Information About Persons Interpersonal And Social Relationships and Music

1. What is the concern? What song do you listen to that helps you deal with the concern? I Got 5 On It

Drugs.

2. What events take place regarding the concern?

When I'm at or around people who use.

3. What events take place regarding the concern?

I usually end up getting high and acting stupid.

4. What happens next?

I get cought or in trouble

5. Who are the people involved?

Myself and friends

6 How do you handle the problem?

I would just get even more high.

7. What are the natural consequences?

I ended up in jaile.

8. How do you draw closure to this problem?

I can and will quit doing drugs.

 THESE QUESTIONS ARE SEQUENTIALLY ORDERED NUMBERS 1-8 AND ALL
WORK TOGETHER.

 Created By Earl S. Lee M.Ed.

Specific Information About Persons Interpersonal And Social Relationships. Detailed Information About Persons Interpersonal And Social Relationships and Music

1.　　What is the concern?

The problem for me was back talking.

What song do you listen to that helps you deal with the concern? <u>Mama</u>

2.　When does the concern arise?

When parents or persons in charge would tell me what to do

3.　What events take place regarding the concern?

I would get yelled at or punished

4.　What happens next?

I would get yelled at or punished

5.　Who are the people involved?

School staff, parent, anyone in charge

6.　How do you handle the problem?

The way I should handle the problem is just do what I'm told unless it hurts me

7.　What are the natural consequences?

My not get what I want, and I may have to do more then what I regually hand to do

8. How do you draw closure to this problem?

I must learn to keep my mouth shut and just do what I was told.

 THESE QUESTIONS ARE SEQUENTIALLY ORDERED NUMBERS 1-8 AND ALL WORK TOGETHER.

<div align="right">Created By Earl S. Lee M.Ed.</div>

Specific Information About Persons Interpersonal And Social Relationships. Detailed Information About Persons And Social Relationships and Music

1. What is the concern? What song do you listen to that helps you
 deal with the concern? <u>Its My Thang</u>

Anger

2. When does the concern arise?

When told to do something I don't want to do.

3. What events take place regarding the concern?

I get mad and start breaking things.

4. What happens next?

The cops come talk to me about what happened.

5. Who are the people involved?

Friends & family.

6. How do you handle the problem?

Talk it over.

7. What are the natural consequences?

Grounded/kicked out or juvenile for a night.

8. How do you draw closure to this problem?

Take anger management classes or talk to people more about how I feel.

THESE QUESTIONS ARE SEQUENTIALLY ORDERED NUMBERS 1-8 AND ALL WORK TOGETHER.

Created By Earl S. Lee M.Ed.

Specific Information About Persons Interpersonal And Social Relationships. Detailed Information About Persons interpersonal And Social Relationships and Music

1. What is the concern?

Acahol

What song do you listen that helps you deal with the concern? <u>Chillin on Gin and Juice</u>

2. When does the concern arise?

Going to a party

3. What events take place regarding the concern?

End up drinking.

4. What happens next?

We go to driving

5. Who are the people involved?

Myself. And my boyfriend

6. How do you handle the problem?

Just drive more.

7. What are the natural consequences?

We will wreck or get caught drinking and driving.

8. How do you draw closure to this problem?

Quit drinking.

 THESE QUESTIONS ARE SEQUENTIALLY ORDERED NUMBERS 1-8 AND ALL WORK TOGETHER.

Created By Earl S. Lee M.Ed.

Specific Information About Persons interpersonal And Social Relationships. Detailed Information. About Persons Interpersonal And Social Relationships and Music

1. What is the concern?

My Anger

What song do you listen to that helps you deal with the concern? <u>California knows How to Party</u>

2. When does the concern arise?

People make me made esey.

3. What events take place regarding the concern?

I cuss them out.

4. What happens next?

I walk away or we get in a fight.

5. Who are the people involved?

Me and people around me.

6. How do you handle the problem?

I wolk away.

7. What are the natural consequences?

Jell or hert.

8. How do you draw closure to this problem?

By going to classes.

 THESE QUESTIONS ARE SEQUENTIALLY ORDERED NUMBERS 1-8 AND ALL WORK TOGETHER.

<div align="right">Created By Earl S. Lee M.Ed.</div>

SECTION 6

Regarding the spelling on the Lee Narrowing Form, no spelling or sentence structure was corrected.

Lee Technique For Narrowing Down When Trauma Occurred and What The Trauma Is and How The Trauma Shaped Your Present Personality.

The first question asked must be to have the person:

1. Think of their best song when in grade school.

Silent Night – Gloria Estefan

2. Their best song when in middle school.

Norteno killer – Aztec prophecy

3. Their best song while attending high school.

Can't stop the southland – Brownside

4. Their best song presently.

Dear Mama – Tupac Shakal

5. Their most traumatic song.

Last day – Brownside.

What is the song that best describes you and your life and why?

Another crazy day – Because I did everything the song talked about everyday. Shootings, tagging, running from the cops.

What song describes that special person in your life and why?

(Mom) Dear Mama – Because my mom went through so much trouble to raise me and my sister and I all I did was bring her problems.

(Son) Just the 2 of us – because all I want to do is go through life helping my son.

Lee Technique For Narrowing Down When Trauma Occurred and What The Trauma Is and How The Trauma Shaped Your Present Personality.

The first question asked must be to have the person:

1. Think of their best song when in grade school.

Twinkle Twinkle little star

2. Their best song when in middle school

Nirvana/Nevermind

3. Their best song while attending high school.

Pantera/Hostile

4. Their best song presently.

Metallica/one and fade to black

5. Their most traumatic song.

Lonestar/Amazing

What is the song that best describes you and your life and why?

Tom petty you don't know how it feels/Pink Floyd. Tom petty because no one knows how it feels to be me. Comfortably num. Pink Floyd comfortably num is because I was always on drugs. Num.

What song describes that special person in your life and why?

Shania twain/ its in the way because it told just how my husband made me feel. He was the best thing that ever happened to me.

Lee Technique For Narrowing Down When Trauma Occurred and What The Trauma Is and How The Trauma Shaped Your Present Personality.

The first question asked must be to have the person: *little boy blue*

1. Think of their best song when in grade school.

Little Gay Blue

2. Their best song when in middle school.

Warren/G Regulators

3. Their best song while attending high school.

Korn/freak on a leash

4. Their best song presently.

Limb Bizkit/Faith

What is the song that best describes you and your life and why?

2 Pac shorty want a be a thug because I was constantly trying to hard to be who I was not.

What song describes that special person in your life and why?

Tom Petty/Last dance with Mary Jane because I can't be with my exgirlfriend write now because Im locked up and it split us up.

Lee Technique For Narrowing Down When Trauma Occurred and What The Trauma Is and How The Trauma Shaped Your Present Personality.

The first question asked must be to have the person:

1. Think of their best song when in grade school.

Little boy blue.

2. Their best song when in middle school.

Nirvana, Metallica

3. Their best song while attending high school.

Master P. It always feel like.

4. Their best song presently.

I wista

5. Their most traumatic song.

Mast P my wall room

What is the song that best describes you and your life and why?

It always feel like from Master P
When I was smoking weed I always though that someone is watching me

What song describes that special person in your life and why?

To you Mamma by 2 Pac because It remind me of my mom.

Lee Technique For Narrowing Down When Trauma Occurred and What The Trauma Is and How The Trauma Shaped Your Present Personality.

The first question asked must be to have the person:

1. Think of their best song.

Ant Banks Cellycel

2. Their best song when in middle school.

Juvinile 100 degrees (guna let Kim punk ya nun)

3. Their best song while attending high school.

Mystical (still smoking)

4. Their best song presently.

DMX and then there was X

5. Their most traumatic song.

2 Pac Dear Mama

What is the song that best describes you and your life and why?

Gangsta's Paradice because I'm always strolling around in city's and looking back at my life and rilizeing there not jeff.

What song describes that special person in your life and why?

The Crystal Method because my mom always gets things done when they need to be done and does it quick.

Lee Technique For Narrowing Down When Trauma Occurred and What The Trauma Is and How The Trauma Shaped Your Present Personality.

The first question asked must be to have the person:

1. Think of their best song when in grade school.

Little Boy Blue

2. Their best song when in middle school.

TRU

3. Their best song while attending high school.

Mystikal

4. Their best song presently.

Lil Wayne

5. Their most traumatic song.

Shuiea Twayn

What is the song that best describes you and your life and why?

Luneys Lundys Because I always have money on some weed.

What song describes that special person in your life and why?

2 Pac Dear Mamma because it reminds me of my mom.

Lee Technique For Narrowing Down When Trauma Occurred and What The Trauma Is and How The Trauma Shaped Your Present Personality.

The first question asked must be to have the person:

1. Think of their best song when in grade school.

Twinkle, twinkle, little star

2. Their best song when in middle school.

Toopac

3. Their best song while attending high school.

Master P & C-Murder, It's like a jungle sometimes, stop all this haters.

4. Their best song presently.

Snoopdoggdog, Top dog

5. Their most traumatic song.

I miss my homie (Master P.)

What is the song that best describes you and your life and why?

I love my Homie Camarada Till the day i die (by Dark Room family) because I love my best homeboy till the day i die cause we have been threw a lot of stuff together we have lived the gangster live together we got in fight together been jumped together and got jumped in the gang together.

What song describes that special person in your life and why?

To my mom Dear Momma (by tupac)

Lee Technique For Narrowing Down When Trauma Occurred and What The Trauma Is and How The Trauma Shaped Your Present Personality.

The first question asked must be to have the person:

1. Think of their best song when in grade school.

Run DMC's Nercery Tymes Peter Piper or Inspector Gadget

2. Their best song when in middle school.

2Pac all eyes on me

3. Their best song while attending high school.

White Zombie living dead girl

4. Their best song presently.

Seven Dust the way you made me feel or feel like you

5. Their most traumatic song.

Metallica (Black) nothing else matters

What is the song that best describes you and your life and why?

Night and White Satin Moody Blues get it and I'll explain and describe why

What song describes that special person in your life and why?

2 pac Dear Mamma cause even though she made it hard for us growing up and put us in bad situations and me and my older brother have different dad's I still love her and give thanx for her raising me.

Lee Technique For Narrowing Down When Trauma Occurred and What The Trauma Is and How The Trauma Shaped Your Present Personality.

The first question asked must be to have the person:

1. Think of their best song when in grade school.

12 Gates

2. Their best song when in middle school.

Agent double O deuce 4 blocc.

3. Their best song while attending high school.

Mr. 357, 25 to life, you best check yo bitch

4. Their best song presently.

Creepin with my mask on

5. Their most traumatic song.

Boxers and Chuck Taylors

What is the song that best describes you and your life and why?

Everyday is a Windy Road. B/C it is that's the way I feel on a daily basis b/c life isn't easy and it's definately not a straight road for me.

All Eyes on Me B/C everywhere I go literally all eyes are on me be it negative or positive.

I sing b/c I'm I'm happy b/c I find myself singing a lot when I'm happy.

What song describes that special person in your life and why?

My nephews: I sing b/c I'm happy b/c that's what we sing to each other
Mom; Silver/gold b/c she reminds me of silver and gold.
Boyfriend; nothing even matter. Lauryn Hill & DeAngelo

Lee Technique For Narrowing Down When Trauma Occurred and What The Trauma Is and How The Trauma Shaped Your Present Personality.

The first question asked must be to have the person:

1. Think of their best song when in grade school.

Vinalla Ice

2. Their best song when in middle school.

Mystical

3. Their best song while attending high school.

Aunt banks, Hanging on the streets of oakland

4. Their best song presently.

Juvinile 400 dg rollin in my benz'a

5. Their most traumatic song.

Dear Mama 2 pac

What is the song that best describes you and your life and why?

Dear Mama because it is talking about how he respect his mom and him out doing drugs and selling

What song describes that special person in your life and why?

Crystal Method because my mom is always up and going.

References

1. Plato, Timaeus and Critias, Desmond lee, Trans. (London: Penguin, 1977), p. 65.

1. Anthony Storr, Music and the Mind (New York: The Free Press, 1992). Cover.

Introduction

2,3,4,5,6,7 Anthony Storr, Music and the Mind (New York: The Free Press, 1992, ix,x. 8,9,10,11,12,13,14,15,16,17,18,19,20,21,22,23,24,25,26 Anthony Storr, Music and the Mind (New York: The Free Press) pp 1,3,4,12,14,26,27

Sexually Abused Children: Helping Them Open…

1. London: Penguin, 1977, p. 65.

Bibliography

Blacking, John, "A Commonsense View of All Music", (Cambridge: Cambridge University Press, 1987)

Burrows, David, Sound, Speech, and Music (Amherst: University of Massachusetts Press, 1990).

Hardy, G.H., A Mathematician's Apology (Cambridge: Cambridge University Press, 1940).

Plato, Timaeus and Critias, Desmond Lee (London: Penguin, 1977).

Storr, Anthony, Music and the Mind (New York: The Free Press, 1992).

Additional Reading

H.J. Devlin and D.D. Sawatzky, "The Effects of Background Music in a Simulated Initial Counselling Session with Female Subjects," Canadian Journal of Counselling, 1987, 21, pp. 125-132.

R. Brim, "The Effect of Personality Variables, Dogmatism, and Repression-Sensitization Upon Response to Music," Journal of Music Therapy, 1978, 15, pp. 74-87.

B.L. Harper, "Say It, Review It, Enhance It with a Song," Elementary School Guidance and Counseling, 1985, pp. 218-221.

M. Priestley, "Music and the Shadow," Music Therapy, 1987, 6, pp. 20-27.

L. Summer, "Guided Imagery and Music with the Elderly," Music Therapy, 1981, 1, pp. 39-42.

M.H. Thaut, "The influence of Music Therapy Interventions on Self-rated Chances in Relaxation, Affect and Thought in Psychiatric Prisoner-Patients," Journal of Music Therapy, 1989, 23, pp. 155-166.

C.A. Smith and L. W. Morris, "Differential Effects of Stimulative and Sedative Music on Anxiety, Concentration and Performance," Psychological Reports, 1977, 41, pp. 1047-1053.

About the Author

 Earl Lee has a Masters degree in Education. He is a Master Teacher working on a second Masters in Education Administration. He is a Principal, teacher of at risk, alternative schools, the Elite program that was featured in Phi Delta Kappan. Lee is a Washington State Certified Teacher, Trained by Dr. William Glasser, Trained in Mora I Reconnation therapy, EMDR[th], SCTD[th], VDK, and NLP[th]. An Apex Private School Superintendent, Principal, Chief Administrator, Mental Health Vocational Case Manager, and Mental Health Case Manager, Lee was on the Mental Health Oversight Committee for Juvenile Concerns for Washington State. He started L&H Comprehensive Counseling Services, and is a family/child expert. He is the owner of Apex professional and personal services; duties counseling services for family, juveniles, drug and alcohol, mentor training, staff development, personal affairs, and gang workshops. Lee is a boot camp counselor in charge of anger management conflict resolution and mental health concerns. Wrote book regarding gangs and educational programs that work for gangs. He is a peer tutoring supervisor and has received numerous awards for community service. Presently, he is putting together a music therapy program for New York City Schools.

Printed in the United States
By Bookmasters